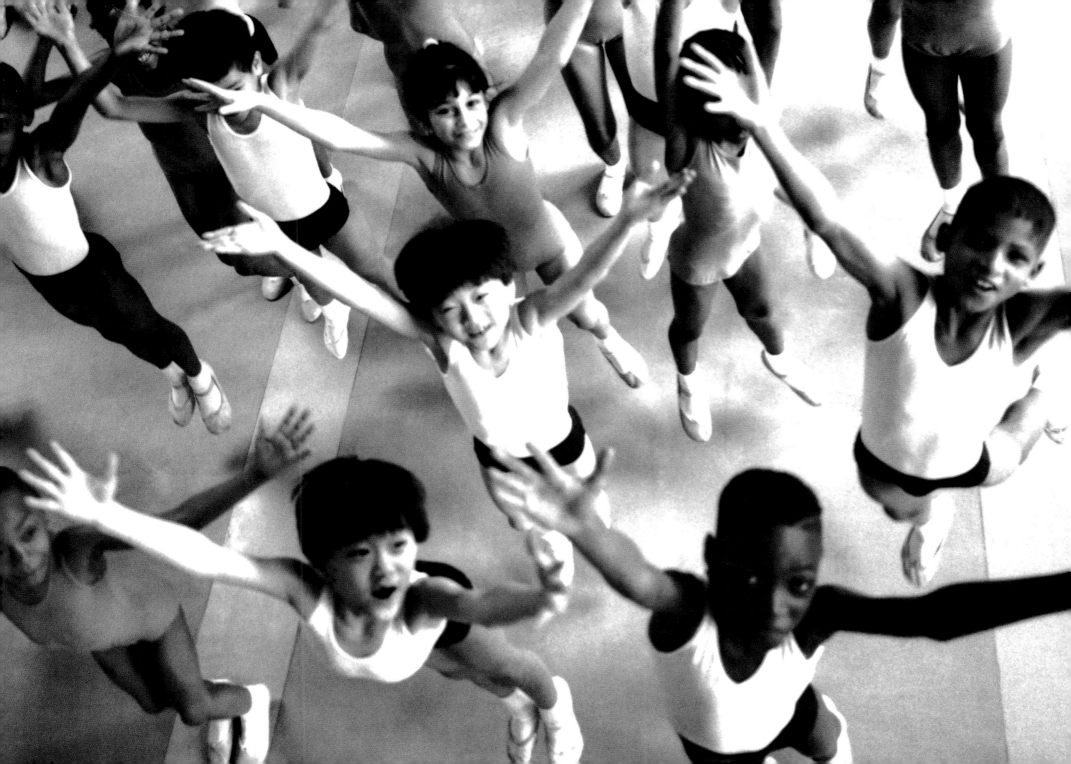

TEXT

and

PHOTOGRAPHS

by

JIM VARRIALE

with

a foreword by

ELIOT FELD

DUTTON CHILDREN'S BOOKS

**T**HE **S**TUDENTS OF **B**ALLET **T**ECH

DANCE

NEW YORK

Many thanks to Eliot Feld and all the teachers,
administrators, staff, and students at Ballet Tech.
This book offers just a glimpse of their enormous talent,
energy, and passion.

To my wife, Christine Sarry, whose great gift for teaching
children is surpassed only by her love for them

Text and photographs copyright © 1999 by Jim Varriale
Foreword copyright © 1999 by Eliot Feld

*Library of Congress Cataloging-in-Publication Data*
Varriale, Jim.
Kids dance: the students of Ballet Tech / text and photographs by
Jim Varriale; foreword by Eliot Feld.
—1st ed.   p.   cm.
Summary: Explores ballet and dance training, as experienced by the
students of Ballet Tech, America's first public school for ballet.
ISBN 0-525-45536-1 (hc)
1. Dance for children—United States—Juvenile literature. 2. Ballet Tech
(New York, NY)—Juvenile literature. [1. Ballet Tech  (New York, NY)
2. Ballet dancing. 3. Ballet.] I. Title
GV1799.V37   1999   792.8'083'0973—dc21   98-55905   CIP   AC
Published in the United States 1999 by Dutton Children's Books,
a division of Penguin Putnam Books for Young Readers
345 Hudson Street, New York, New York 10014
http://www.penguinputnam.com/yreaders/index.htm
Designed by Amy Berniker
Printed in Hong Kong   First Edition
10 9 8 7 6 5 4 3 2 1

# FOREWORD

**I**magine your whole body singing. Your legs and your arms, your toes to your nose, all singing. Trilling, then rapping or scatting, maybe whooshing in whispers or at the top of your lungs. That's dancing! Yes, dancing is like singing with your whole body. For some people, and that includes me, there is nothing that feels better than dancing.

Almost everybody dances. Most people dance once in a while, just for the fun of it. But some of us like it so much we never want to stop dancing. When I was eleven years old and had the living room all to myself, I would turn on some music—almost any music, but of course I had my favorites—and dance and dance until I was sweating and all out of breath. Yup, I knew I wanted to be a dancer when I was eleven.

Dancing, especially ballet dancing, is very difficult. Hard fun, if you know what I mean. You have to learn to jump and turn, to point your feet and stretch your legs and arch your back while your arms and head are doing different things, all at the same time. There is a lot more a dancer needs to learn, too much to name here. It takes a ton of work, good teachers, a lot of patience, and thousands of classes to learn it all!

This book is about the kids who go to Ballet Tech. All of the students at Ballet Tech agree about one thing: they all love to dance, and most of them want to become professional dancers. They remind me of an eleven-year-old I once knew. Just like him, they want to dance and dance until they're sweating and all out of breath.

—ELIOT FELD

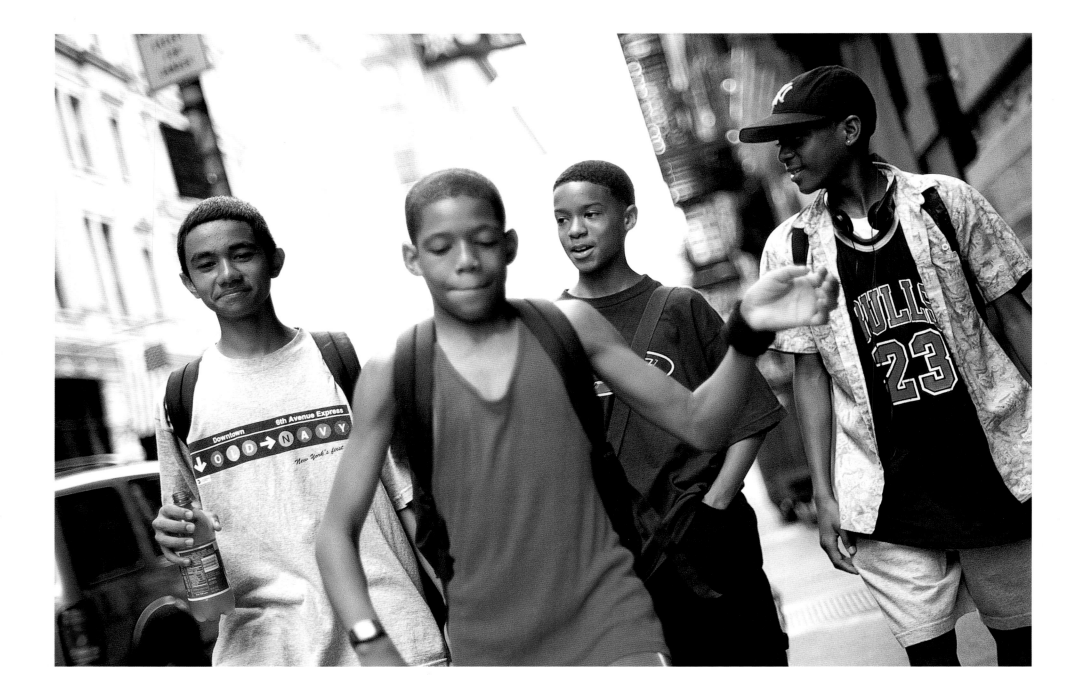

# INTRODUCTION

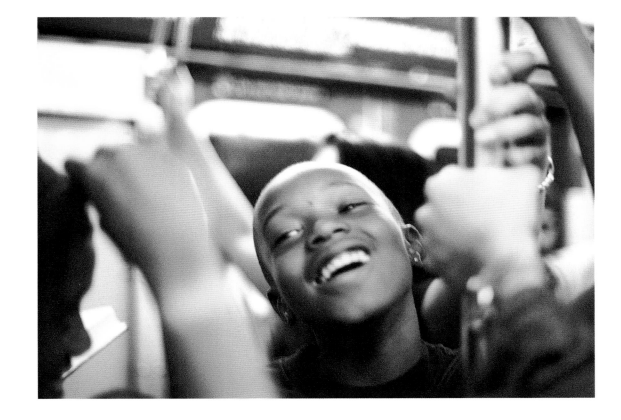

One fall day in 1976, Eliot Feld, a world-renowned ballet choreographer, boarded a subway train in New York City. He was worried about something. Mr. Feld needed more young dancers for his ballet company, but well-trained ones were difficult to find.

The subway car was noisy; Mr. Feld was distracted from his thoughts by a group of students on a field trip. They were laughing, talking, poking one another, squirming around. They made Mr. Feld smile a little. And then they made him smile a lot. He had an idea. Why not look for dance talent in the New York City public schools? Watching these children, he knew he could find energetic youngsters in the schools and train them to be the kind of dancers he needed. And so he started a special school for dance, one where young New Yorkers could learn ballet, free of charge. Now, more than twenty years later, thousands of city kids have had the chance to study at Ballet Tech, a public school for dance.

It's a strange day at Public School 321 in Brooklyn. The third-graders have taken off their shoes and are jumping up and down on the auditorium stage. It's not a riot, and it's not even a gym class—it's a dance audition. Over the next few months, third- and fourth-graders at two hundred schools in New York City, thirty-five thousand kids in all, will have this same chance to try out for one very special school—Ballet Tech, a public school for dance.

Ballet is a performing art that uses the human body to create beautiful, meaningful images. Ballet dancers must have excellent control of their movements. To dance well, they must take ballet classes throughout their school years, starting at age eight or nine. Most families cannot afford to pay for so many lessons, but at Ballet Tech, the classes are free, so any child chosen at these auditions can take them.

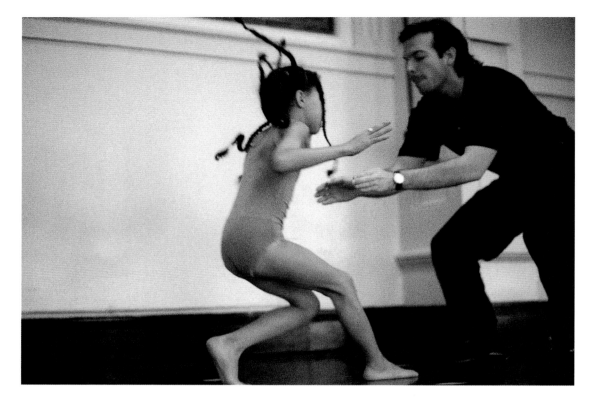

The Ballet Tech teachers look for children who can jump high, stretch their legs and back easily, and march and skip smoothly across the floor. By gently bending each child's foot, they can see if it has the flexibility to point the way a dancer's should. They also look for children with long legs and arms. This type of "ballet body" can create the shapes and positions of dance most beautifully. Just a few children from each elementary school will be invited to attend weekly classes at Ballet Tech.

They just picked me from my school. I didn't know I had a talent for dancing until I got there."
EMANUEL ROBINSON
The Bronx
Age 12

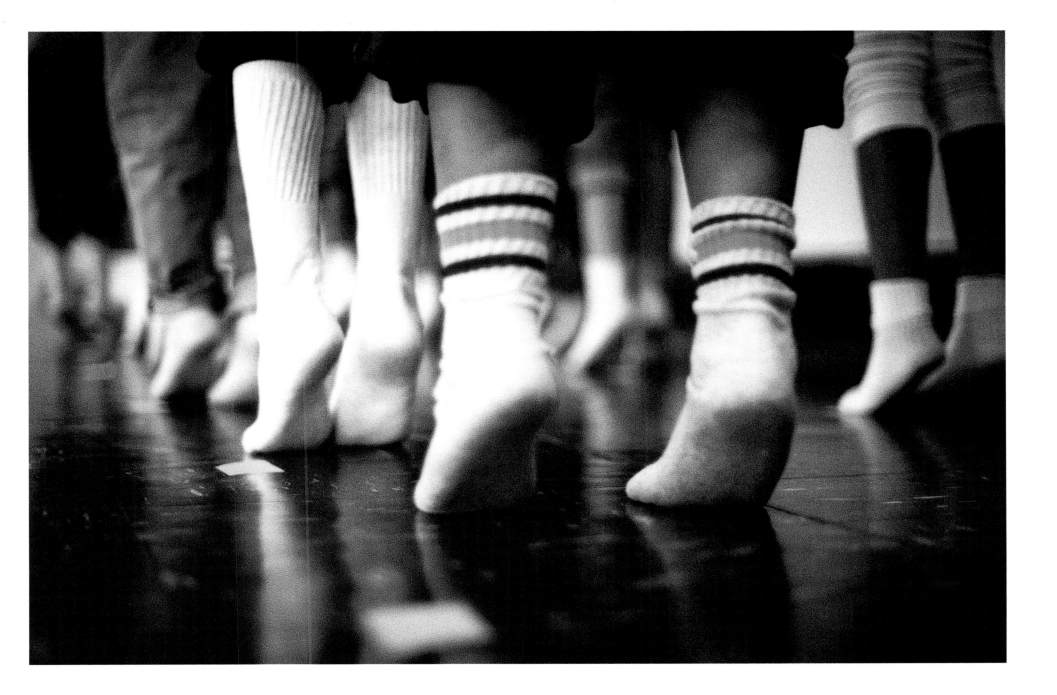

When the auditions are over, the lessons begin for the chosen students. One morning a week, at public schools in every part of New York City, the beginning dancers will board yellow minibuses headed for lower Manhattan. For some, it's the first trip they have taken away from their neighborhood. They enter the school building on Broadway and step into a new world. Their classroom is a huge, sunlit dance studio with a wall of mirrors, a shiny grand piano, and a specially cushioned wood floor. As the children look around, the teachers begin handing them dance clothes.

At Ballet Tech, you can't dance in jeans and socks. Boys are given sleeveless T-shirts and funny-looking tight shorts called trunks to wear. The girls are given leotards. And

"The first reaction from most of the boys is like, 'Underwear! Where's the rest of it?' You get used to it."
LAUMONTE WILLIAMS
Queens
Age 12

there are ballet shoes for everyone. These dance clothes are stretchy enough to allow the children freedom to move, but they are also formfitting so the teachers can see the shapes the students make with their bodies. These shapes are part of the visual "language" of ballet, the way dancers "speak" to an audience about the ideas or feelings in a dance.

But before they change their clothes, the children listen intently to the rules of the school:

1 Show respect to your peers and teachers.
2 Make good use of time before class.
3 No running in the halls.
4 No eating or talking during class.

Dance is fun, but it's serious, too.

The children put on their new clothes. The dance teacher tells them, "Time to stretch."

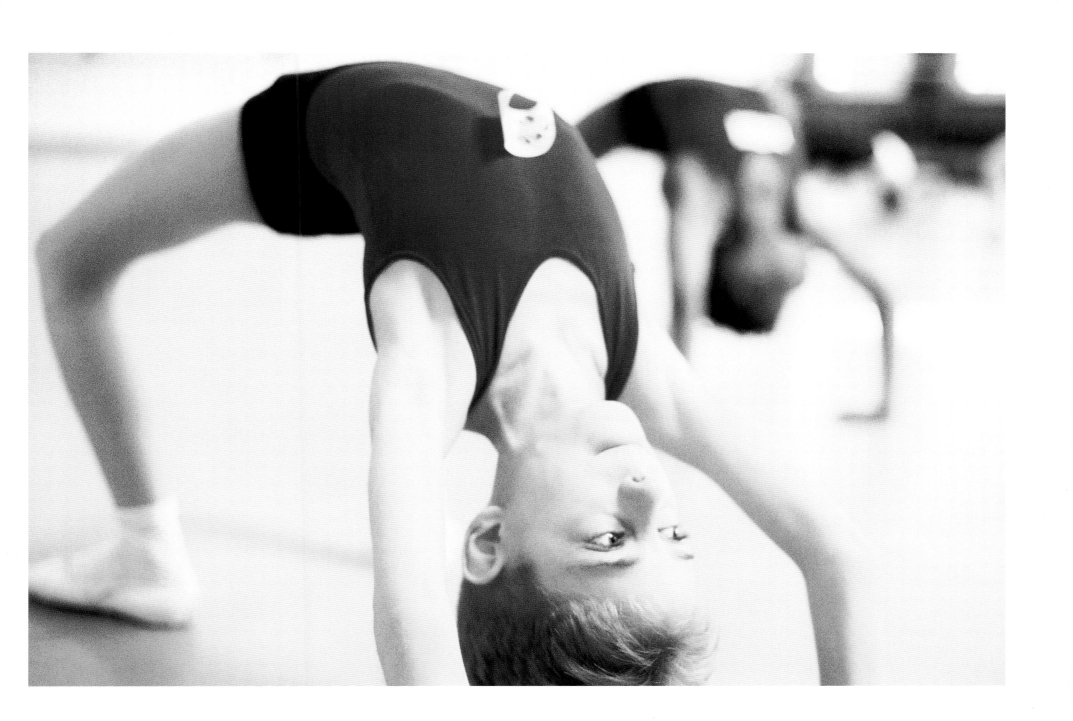

"You have to listen to the teacher. If you don't listen, it ain't gonna go right. If you listen, you'll go smooth. That's how I got where I am now—by listening."
EMANUEL ROBINSON
The Bronx
Age 12

With their muscles loosened and lengthened from stretching, the children begin a special series of exercises. They start by placing a hand on the barre, a wooden rail attached to the walls of the room. It helps them keep their balance as they learn the basic movements of ballet. Every ballet class the children will ever take, even as professional dancers, will begin with work at the barre.

For hundreds of years, ballet students have performed these same exercises. The teacher explains that these movements have French names because the first formal teaching of ballet began in France. They start with movements called *pliés.* Students bend their legs with their backs straight and their feet turned outward. *Pliés* are generally followed by *tendus,* movements to extend the leg and stretch the foot.

After the barre exercises, a typical ballet class continues in the center of the studio. Now it's time to really move—without the help of the barre. The teacher combines various ballet steps for the students to dance. Some teachers demonstrate their "combinations," as they are called, and then ask the

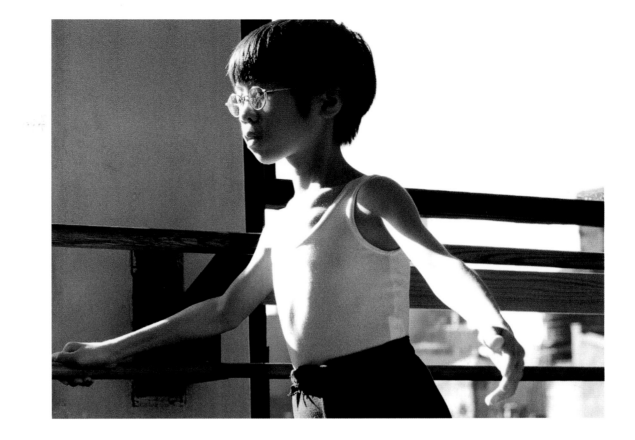

students to repeat them. Others just ask for the steps by name, so it's important to remember them. A teacher might call out, "Chassé, pas de bourrée, glissade, assemblé." With practice, the students will be able to perform the steps without having to pause and think first.

The students dance the combinations in small groups. Slow movements, called *adagio,* are usually danced first, followed by turns and then small quick jumps, called *petit allegro.* The big jumps—*grand allegro*—that launch the dancers across the floor are performed at the end of class. They can be the most fun because they feel like flying!

By dancing the teachers' combinations and listening to the corrections they give, ballet students learn to dance. Class always ends the same way, with bows and applause for the teacher.

Almost a thousand new students are invited to Ballet Tech each year, but only a small number will continue to take classes after the first seven-week session. While the school hopes to introduce many children to ballet, its real purpose is to train professional ballet dancers, young people who will make a career of dancing onstage.

Eliot Feld, the founder of Ballet Tech, says that "Exceptional talent is exceptionally rare." The students who respond well to teaching in the first seven weeks are asked to stay for another session, but after that, even more cuts are made.

Some kids are sad to leave Ballet Tech. They miss the classes and the banter of the bus trips to and from the studios, but they take with them a wonderful experience. They have met children from all across New York City. They have experienced the beauty and power of ballet dancing, and they have worked hard while having fun. Now when they watch a ballet performance, not only will they recognize some of the steps, they will appreciate the extraordinary work and concentration behind the seemingly effortless movements.

Those students who show a great talent and dedication are invited to take more advanced classes. For the next two years, they will come to Ballet Tech twice a week and on Saturdays.

They expect my best! She [the teacher] says, 'If you're going to dance—DANCE! If you're not going to dance—why are you here?'"
ASHA RENEE DAVIS
Queens
Age 10

CUTS

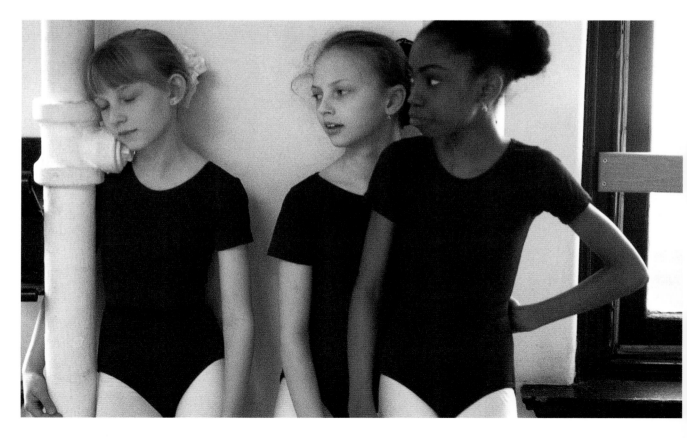

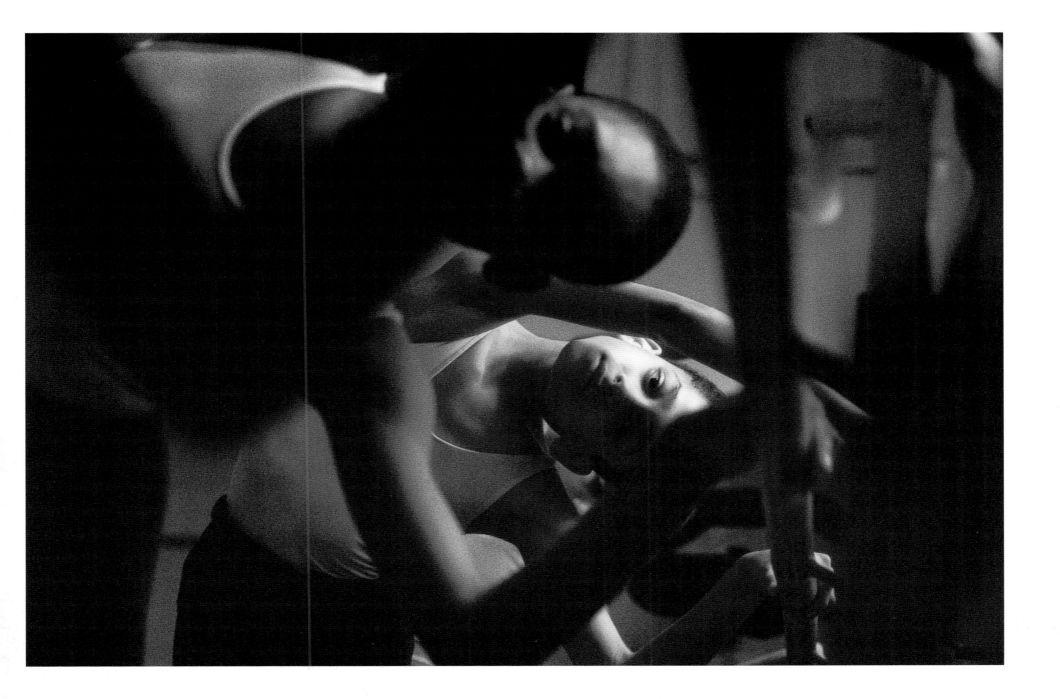

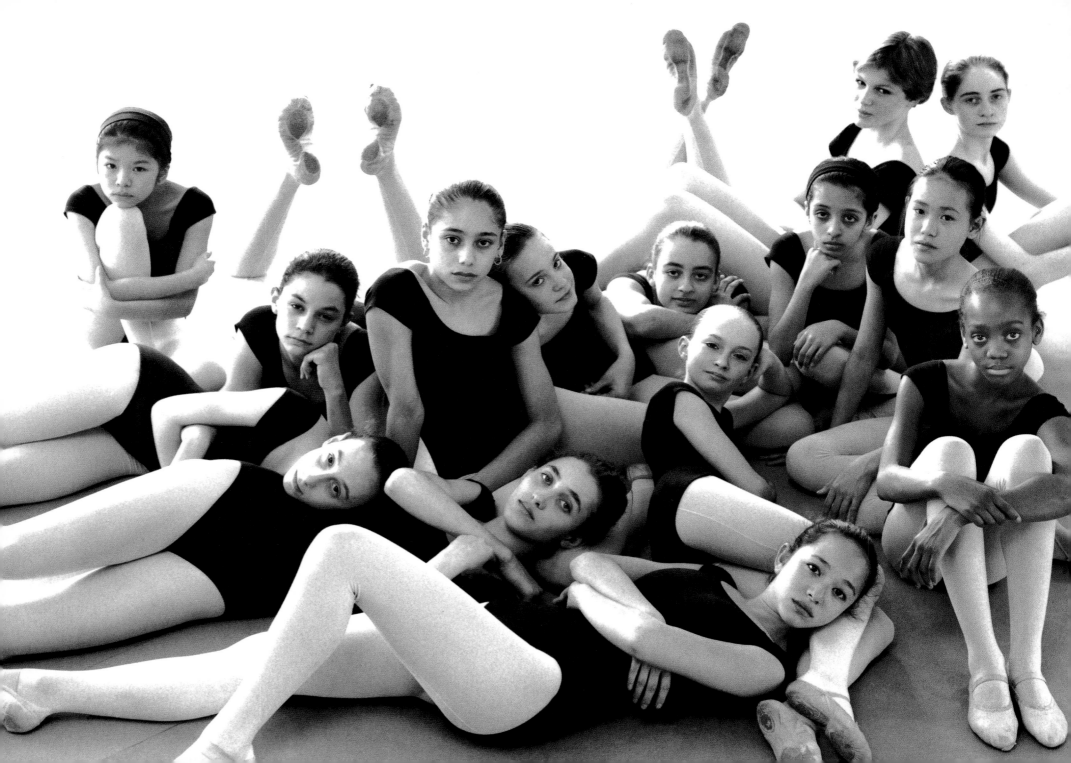

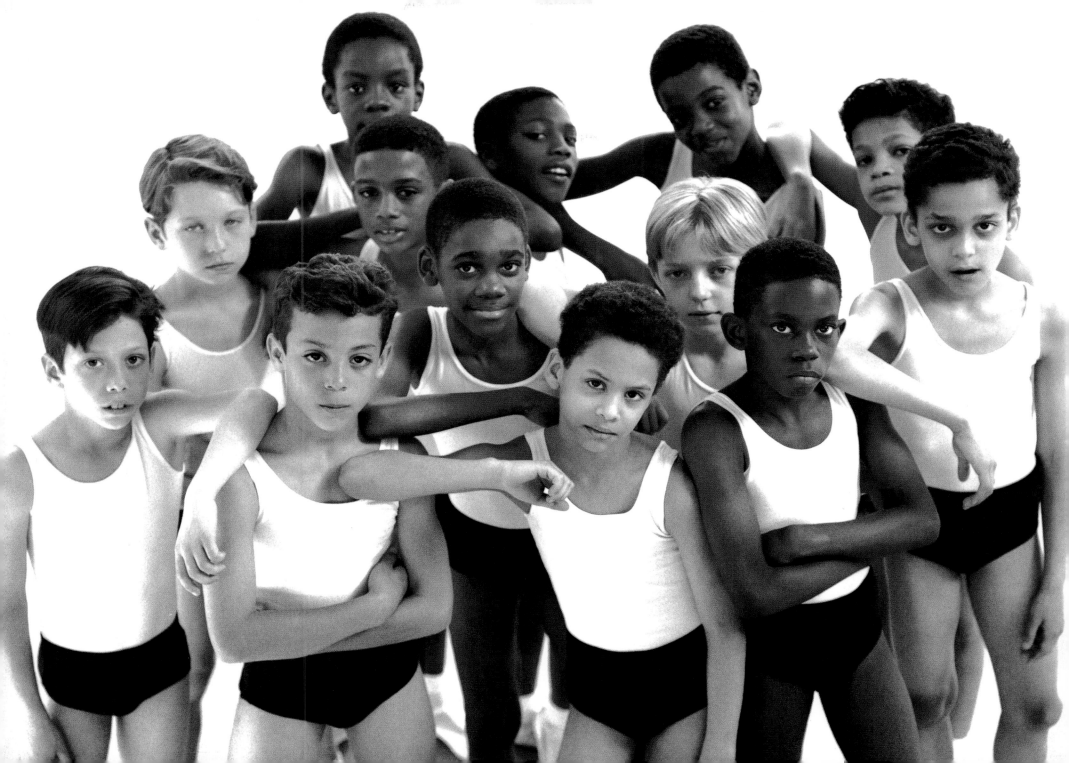

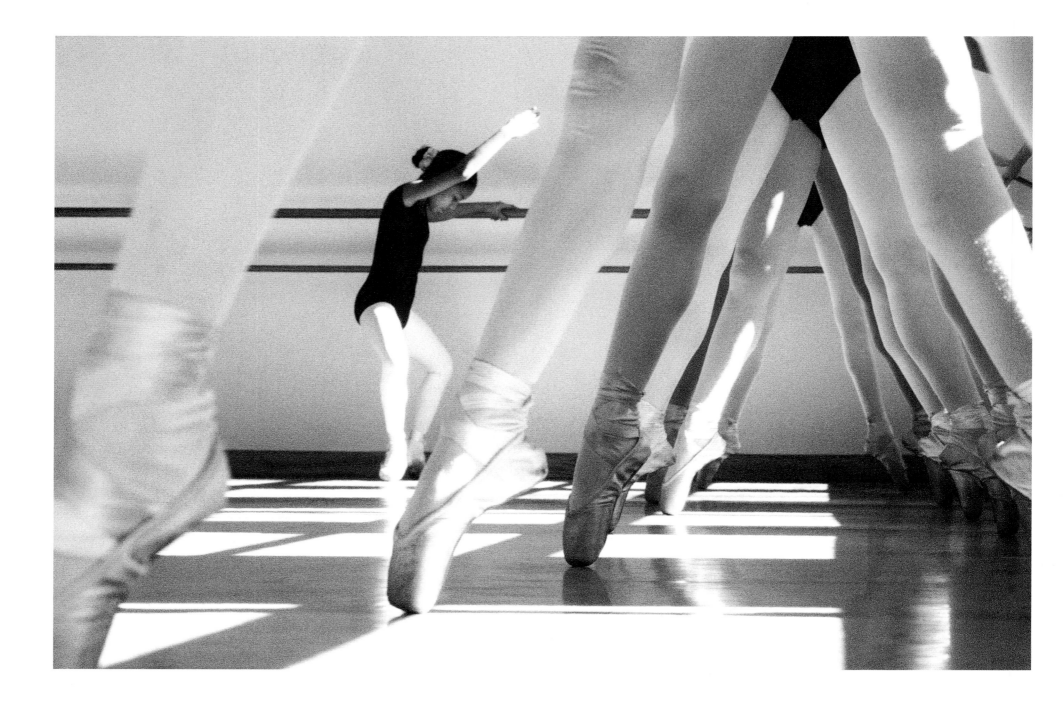

From the time a young girl takes her first ballet class, she looks forward to the day when she will dance "on her toes." As they advance, female ballet dancers usually dance *en pointe* in satin-covered *pointe* shoes that have layers of stiff cardboard and burlap in the toes. These shoes allow girls to balance on their tiptoes, giving their bodies a longer, graceful look. At Ballet Tech, *pointe* shoes are handed out in the sixth grade, after the girls have had two or three years of training and are strong enough to dance *en pointe*.

While holding on to the barre, the girls practice rising up slowly onto the tips of their shoes from a flat-footed position and then slowly coming down. This builds the foot strength and confidence they will need to stand and move on their toes. Most girls are shocked by how much their feet hurt inside the stiff new shoes. They learn an old trick of the trade from their teacher. By first taping their toes, then wrapping them in lamb's wool, they can prevent painful blisters. After a while, tough calluses and strong foot muscles will form, making the *pointe* shoes bearable to wear—almost!

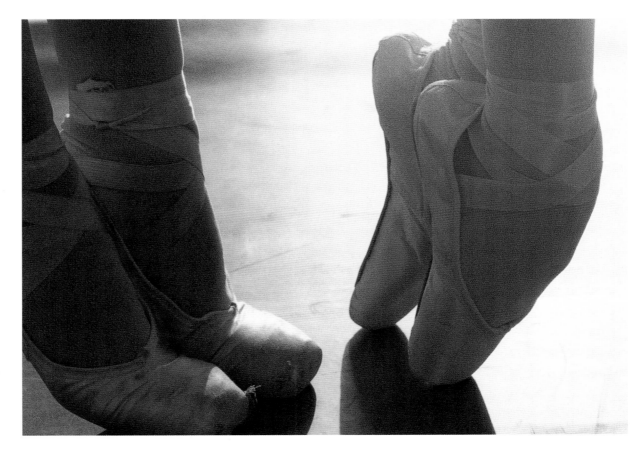

It takes years to learn to dance in *pointe* shoes. Every movement, from flexing the foot to turning and jumping, feels strange. A female dancer works tirelessly, even painfully, to create the illusion of weightless grace given by balancing *en pointe*.

Y ou think you have it down... and you put those suckers on and you can't do a thing. It is so hard!"
PATRICIA TUTHILL
Brooklyn
Age 17

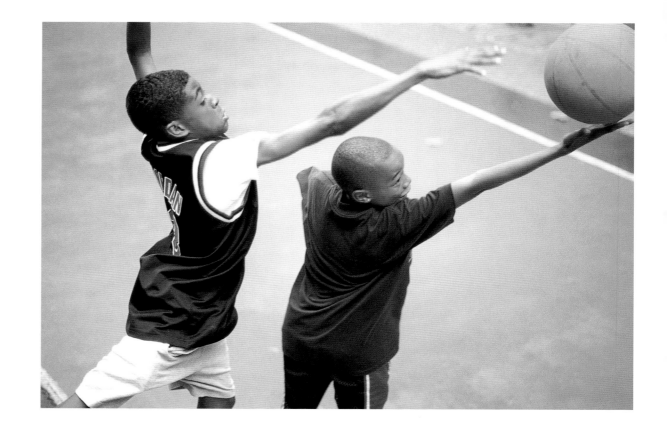

"Ballet is just for girls!" Have you heard that before? Of course, it's not true. With a single leap, a male dancer can seemingly defy gravity and make the audience wait for his descent to the ground. He can launch his female partner into flight and then catch her just inches from the floor. He makes impossible movements appear easy. He can amaze!

At Ballet Tech there are more boys than girls because so many talented boys are seen at the auditions and encouraged to give ballet a try. And the boys at Ballet Tech love to challenge one another. You see, ballet dancers aren't just artists, they are great athletes, too. At the end of every dance class, the boys compete to see who can perform the most pirouettes (turns) and who can jump highest in the air.

Many of the classical ballets were choreographed with women in the lead roles.

Often the male dancer's chief duty was to lift and support his female partner in a dance called a pas de deux. In contemporary ballets—like those that Mr. Feld choreographs—the man's role has changed dramatically. Men now dance alone and in groups with other men as often as they share the stage with women. Ballet needs boys. Male dancers bring great excitement and energy to ballet.

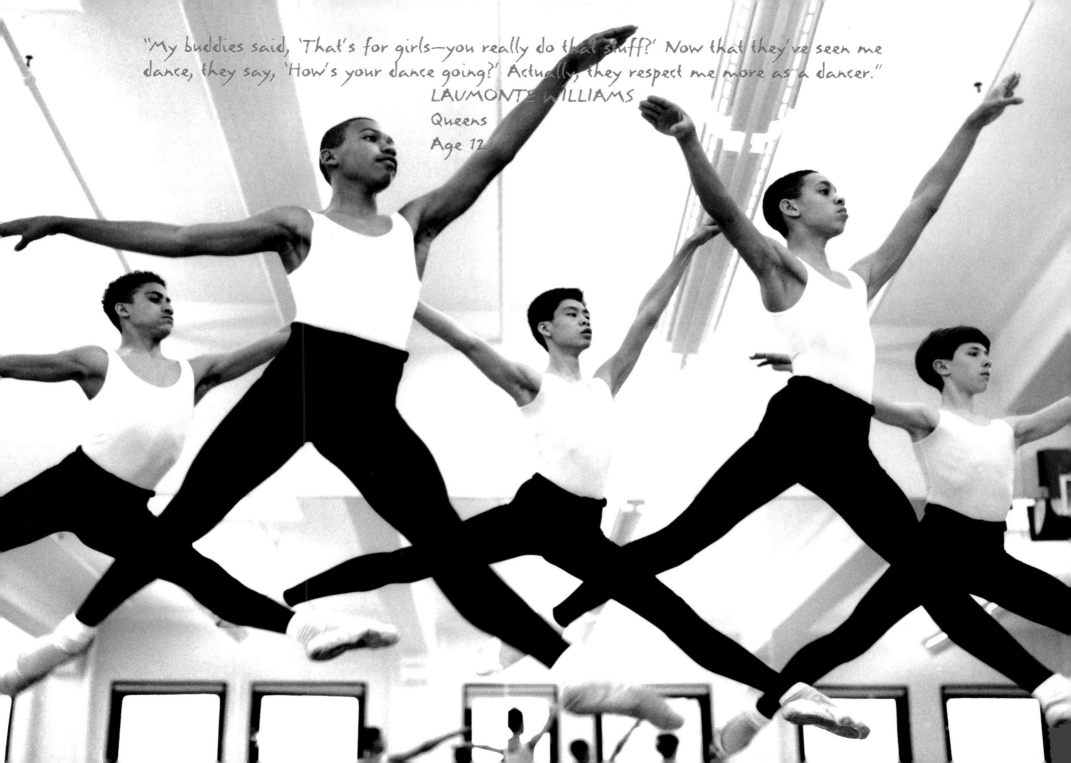

"My buddies said, 'That's for girls—you really do that stuff?' Now that they've seen me dance, they say, 'How's your dance going?' Actually, they respect me more as a dancer."
LAUMONTE WILLIAMS
Queens
Age 12

Starting in the sixth grade, a select group of about twenty students is invited to attend Ballet Tech full-time. They will join the eighty or so middle-grade and high school students who are enrolled in the New York City Public School for Dance, the formal name of Ballet Tech's academic program. Ballet Tech is America's first public school just for ballet dancers.

The students take courses in math, science, English, social studies, French, Spanish, dance history, art, and music. Classrooms with computers, blackboards, *and* a small collection of reptiles are just down the hall from the dance studios. But the students spend about half of their time in the studios.

Academic classes in the morning are followed by several hours of dance class in the afternoon. It's an exhausting schedule. And now, like other city kids their age, they don't have school buses waiting to take them home at the end of the day. After a long subway ride, the students arrive home with barely enough time to eat and study!

Although they live in a big city filled with activities, serious young dancers don't have much free time to explore. Saturdays are often filled with more classes and rehearsals, so there is rarely a chance to hang out with friends. But the sacrifice is worth it. For these kids, nothing is more fun than dancing.

I would go to sleep on the subway after ballet. I'd be like dead tired!"
JASON JORDAN
Manhattan
Age 18

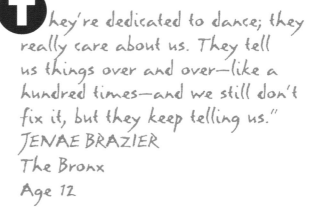

**T**hey're dedicated to dance; they really care about us. They tell us things over and over—like a hundred times—and we still don't fix it, but they keep telling us."
JENAE BRAZIER
The Bronx
Age 12

**D**ance knowledge is passed on from one dancer to another. There are no books that can teach you how to dance ballet. A book might show you a photo or drawing of a certain jump or turn, but only with endless practice, under the guidance of a fine teacher, can your body learn the correct coordination of the movements.

Because Eliot Feld's dance company (also called Ballet Tech) practices in the same studios as the school, the students have the opportunity to learn from professional dancers as well as their teachers. When the dancers in the company are taking their daily ballet class, or rehearsing the ballets they will perform onstage, wide-eyed young students crowd into the studio doorway to watch.

All the teachers at Ballet Tech were once professional ballet dancers themselves. Some are famous and have danced all over the world. They know firsthand how difficult ballet dancing is, so they can prepare their students for what lies ahead. They teach what they have learned from their own experience and from the lessons of teachers they once had. One day these students will teach these same lessons to a new generation of dancers. That's why getting kids interested in dance is so important. Without children to learn it, ballet would die.

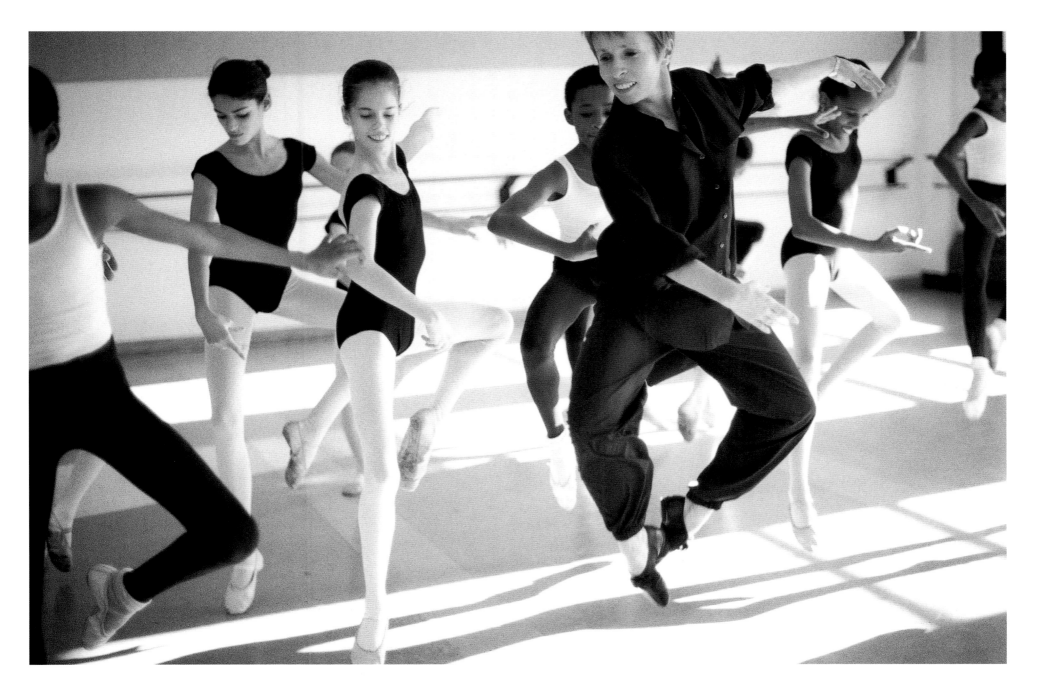

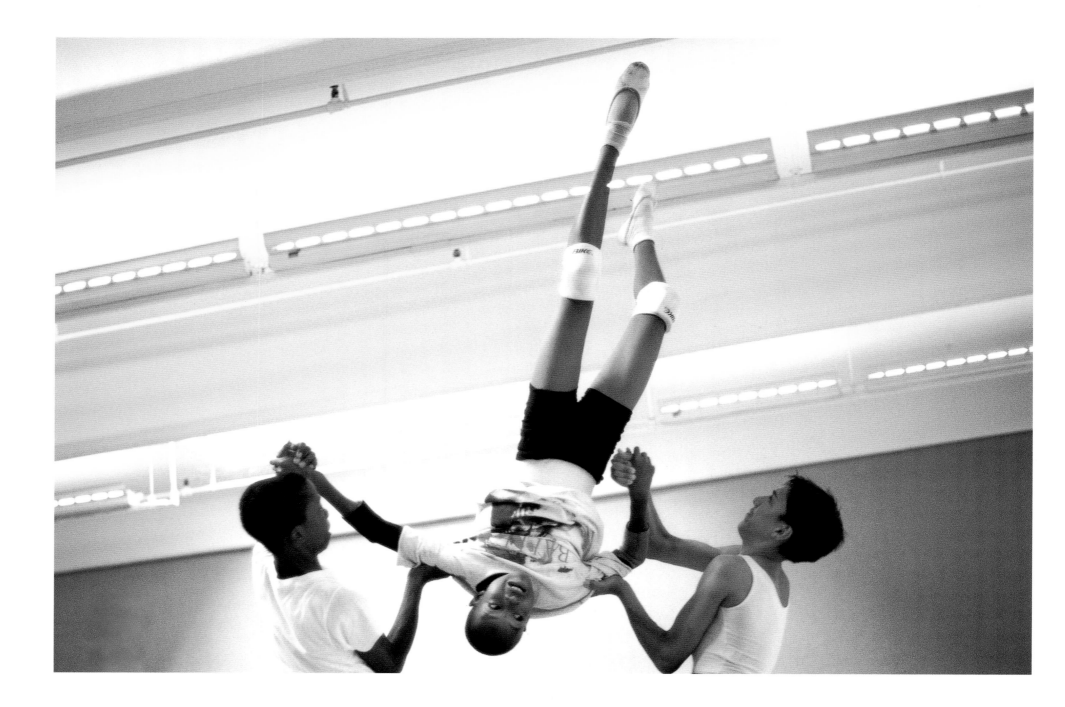

A teacher guides a student's movements in class, but it is a choreographer who shapes the performance of a dancer onstage. Eliot Feld, the founder of Ballet Tech, is a choreographer. He has created more than one hundred ballets for companies of professional dancers and a few just for the students of Ballet Tech.

Choreographing a new ballet is creative, physically demanding work for the choreographer and the dancers. They spend weeks together in the studio, trying out the new steps and movements. They go over them again and again to discover the sequences that best illustrate the mood, idea, or story of the ballet.

Mr. Feld believes that ballet should reflect today's world, and his choreography is often influenced by the everyday experiences of his young dancers. In a section of a ballet called *Simon Sez,* he has a group of ten- to thirteen-year-old dancers perform rhythmic hand-clapping movements much like those you might see at a playground. Many of his dances have a sense of fun. His fantasy ballet *Papillon* features crawling spi-

*Working with a choreographer is great. You get so excited...you get so mad...it's a whole bunch of emotions. You have to be patient—something beautiful will come out of it."*
PATRICIA TUTHILL
Brooklyn
Age 17

ders along with dancing caterpillars and butterflies. Another ballet, called *Meshugana Dance,* requires the boys to perform some comical upside-down lifts.

Ballet is a living and constantly changing art form. Famous ballets like *The Nutcracker* and *The Sleeping Beauty* tell stories from the past, but Mr. Feld and other choreographers want to create ballets about our modern world. They combine the classical movements of ballet with their own newly invented ones to make their work fresh and interesting for audiences of today.

CHOREOGRAPHY

The students at Ballet Tech can hardly wait to dance in front of an audience. Each year they have the chance to participate in *Kids Dance,* a Ballet Tech student performance series.

*Kids Dance* is designed for young people: kids dancing for kids. The performances, which take place in New York and other cities around the country, are packed with schoolchildren. The excitement of dancing onstage is particularly intense in New York, where the Ballet Tech students get to show

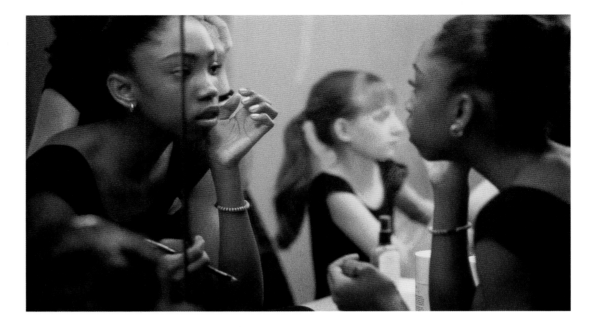

off their new skills to family and friends.

Learning and rehearsing the *Kids Dance* ballets take months of work at school, followed by rehearsals onstage at the Joyce Theater. "The Joyce," once a Manhattan movie theater, was rebuilt just for dance companies to perform in. It has a special extra-wide stage and good views from all 472 seats.

Before every performance, the theater buzzes with energy. An entire team of technicians and company personnel prepares the lights, sets, props, and music for the moment the dancers take the stage. In dressing rooms, the performers apply makeup and

change into their costumes. After what seems like forever, the stage manager issues the "On stage" call.

Waiting in the wings, the young dancers are charged with a kind of electricity. A nervous energy becomes their partner. The audience, seated in the darkness "out front," is invisible yet perceptible. The stage, you see, is very different from the studio. Now there is just one chance to get it right. But the hours of rehearsal have paid off. The excitement of kids dancing for other kids fills the theater. When the performance is over, the hoots, hollers, and applause get very, very loud.

"I love going on the stage. You put on costumes and makeup.... You get nervous at first, but once you're out there, you just dance. You put all your worries behind you."
JULIA SBORDONI
Queens
Age 13

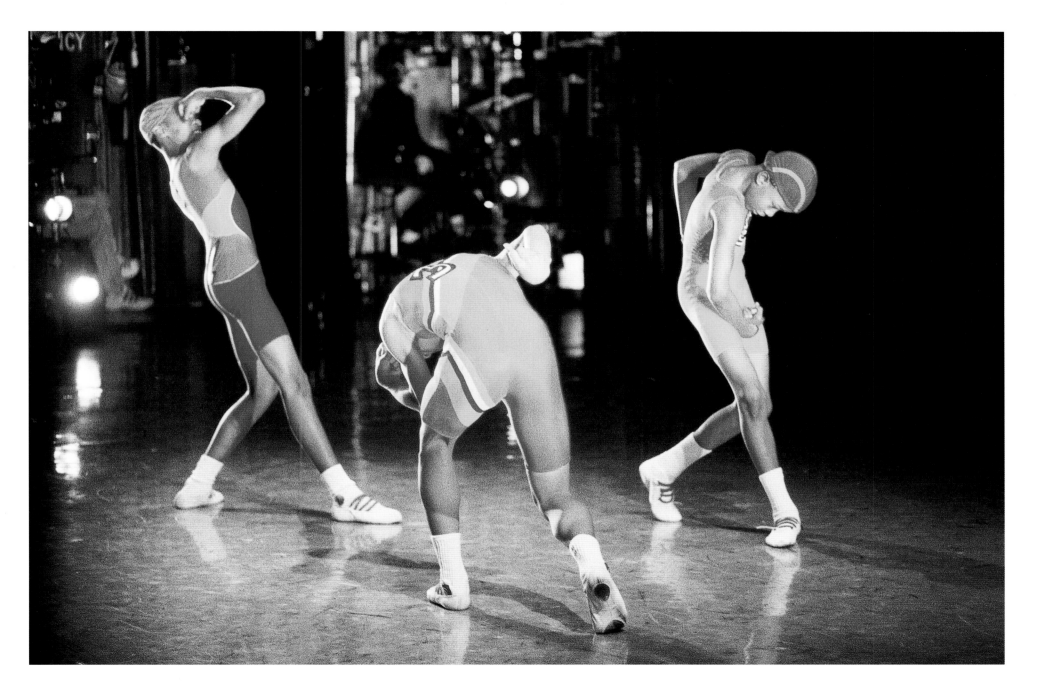

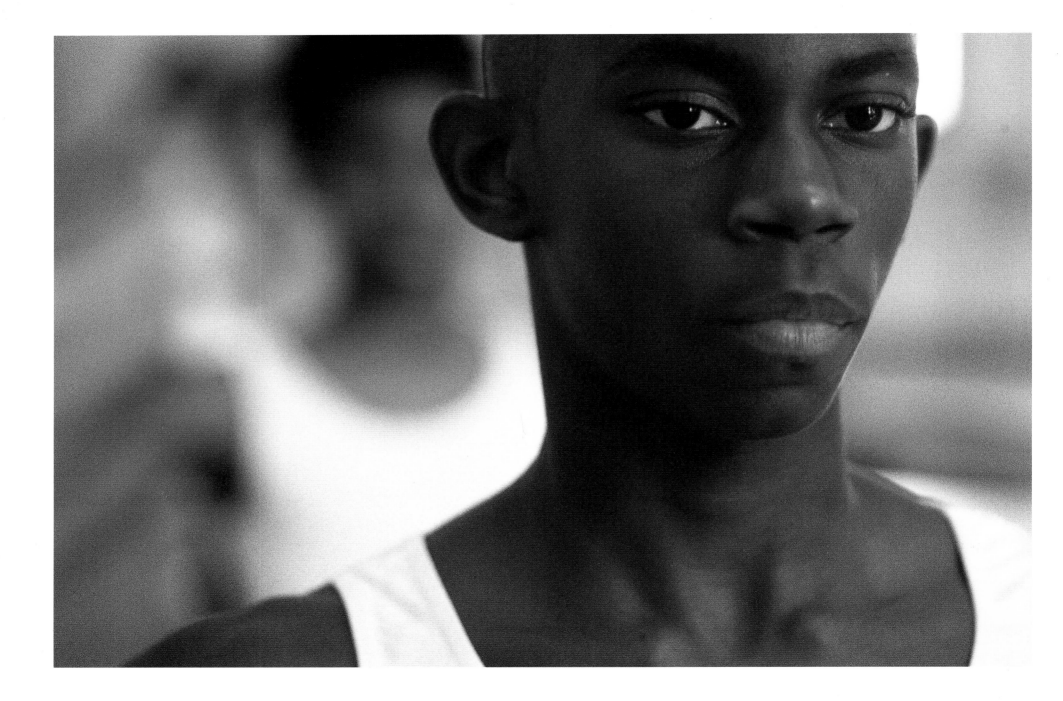

**D**ancing has to be something that you do, I think, only if you love it. It's very hard, but the joy that you receive cannot be measured. No money, no anything could replace that feeling. Some people never feel that in their entire lifetime."
PATRICIA TUTHILL
Brooklyn
Now age 20
Auditioned at Public School 204
Dancer with the Ballet Tech Company since August 1995

**D**ancing on the stage will become a big part of the lives of those who have the talent to become professional dancers. The very best dancers at the Ballet Tech school are invited to become apprentices with the Ballet Tech company. These elite "dancers-in-training" work part-time with the professionals while they continue their regular school studies. They earn money for rehearsals and performances and dance right alongside the company members, all of whom were once Ballet Tech students themselves. After they finish high school, most will be asked to join the company as full members.

Graduation is a time for decision making. It's clear by now who will and who won't be asked to join the Ballet Tech company. The students wonder: Should I audition for another dance company? Do I want to go to college and study dance there? Do I really want to be a dancer? These are tough questions, but whatever the answers, each student will leave school knowing a *lot* about hard work and self-discipline—and success.

And few of these students would ever have known that becoming a ballet dancer was a possibility if it wasn't for that first funny audition. That little jump in the air they made as third-graders has taken them very far indeed; it has given some of them a life many dream of—a life of dance.

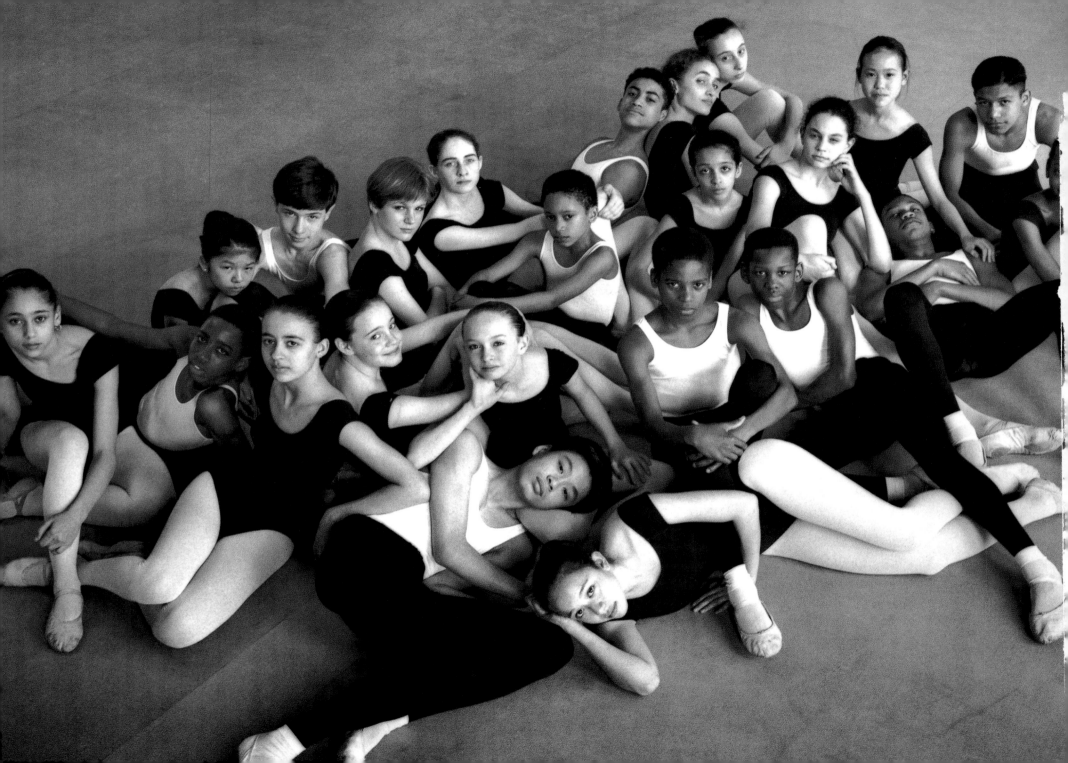